depicting a skipping fisherman with the slogan 'Skegness is so bracing', published in 1908 for the Great Northern Railway. *Ye Berlyn Tapestrie* was one response to the sense of outrage that gripped Britain in 1915. Hassall's vision is however a light-hearted one, playing with aspects of German 'frightfulness'. Taking the most well-known pictorial representation of a foreign invasion, the eleventh-century Bayeux Tapestry, Hassall used the cartoon format to poke fun at the pretensions of the invaders of Belgium and France, drawing attention to the alleged atrocities by claiming that they were simply the inevitable result of the 'kultur' of the Kaiser and 'Prussianism' (or militarism), a theme often emphasised in British propaganda at this time in response to perceived German claims of cultural

su e in ly as ne of barbarism. Hassall uses the stereotypes found in rather more vicious publications but with a great deal more humour. Beer-drinking, gluttonous German soldiers in spiked helmets march into Belgium and Northern France forcing women and children to march in front of them, looting property, deliberately destroying churches and hospitals; poison gas is prepared using Limburg cheese and sauerkraut; and while German officers carouse with looted champagne, the Kaiser 'giveth orders for frightfulness'. Of course the British bulldog and the French hold them up, but this provides more opportunity for dreadful deeds as the Germans resort to sinking

neutral shipping, and dropping bombs (marked 'kultur') from the air, with equally hapless results. There are borders running at the top and bottom of the cartoon-strip, just as in the Bayeux Tapestry, but these ones are filled with jocular references to objects associated in the popular mind with German life and culture such as beer and sausages.

The depiction of the sinking of a merchant ship may refer to the *RMS Lusitania*, which was torpedoed by a German submarine on 7 May 1915. The publication date for *Ye Berlyn Tapestrie* would seem then to be later in 1915, after the sinking of the *Lusitania*, and after the publication of the Bryce Report. A stamp on the Bodleian's copy shows that it was acquired on 5 April 1916.

Ye Berlyn Tapestrie was printed in striking brick-red and black, and comprised five sheets attached along their short edges. It includes thirty cartoon panels, folded concertina-style between its covers. When it is fully open it measures 525cm. Nearly one hundred years on, this highly unusual publication provides a fascinating insight into the culture of the times. Although it perhaps makes for uncomfortable reading in parts, it is nevertheless an authentic contemporary response to the war. From today's perspective, we recognise our shared European experience, and Hassall's preposterous stereotypes make us laugh as much at ourselves as at a people who were once the bitterest of enemies but have for a long time been our partners and friends.

Mike Webb

YE BERLYN TAPESTRIE:

Wilhelm's Invasion
of Flanders:
Pictured by John Hassall:

1s: net:

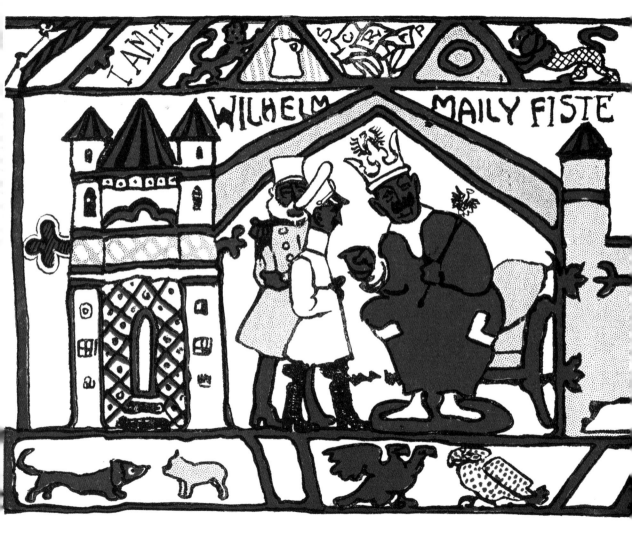

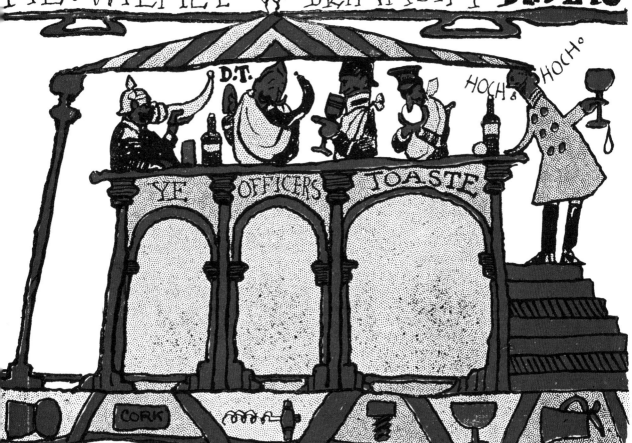

HYS CAREFULE PREPARATIONS FOR WAR

INVENTION OF ye DEADLY GAS

ye doubtful Eggs — ye GERMAN CIGARREN — ye BADGE

LIMBURGER KASE

SAVER KRAVT ESSENZ

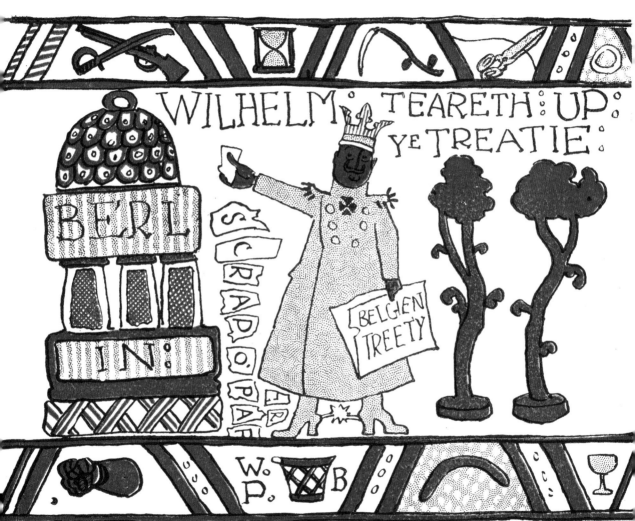

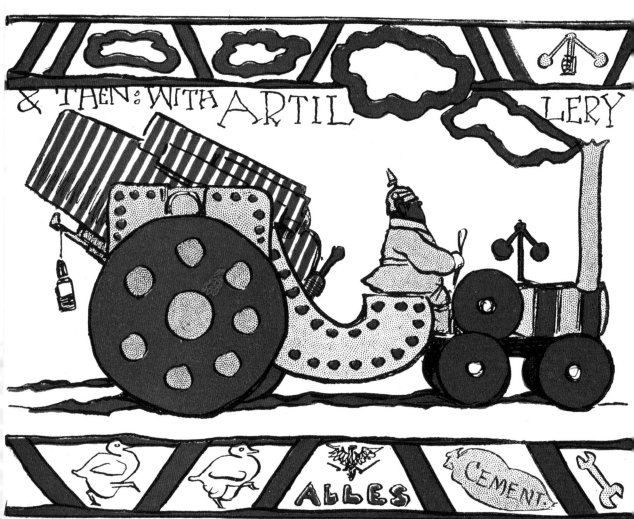

& THEN: WITH ARTIL LERY

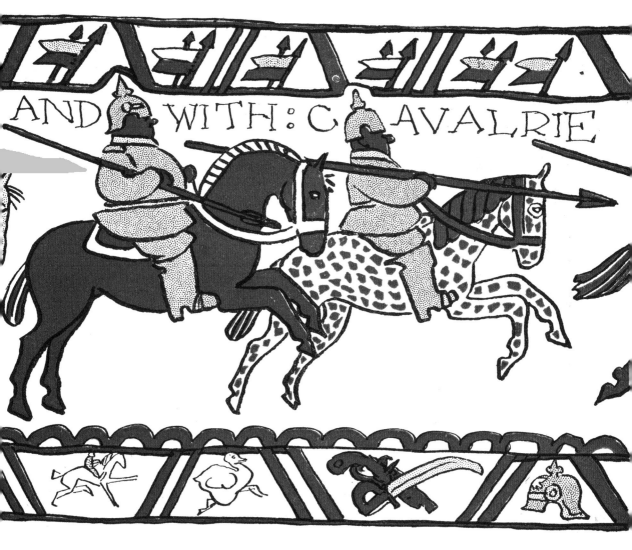

AND WITH: C AVALRIE

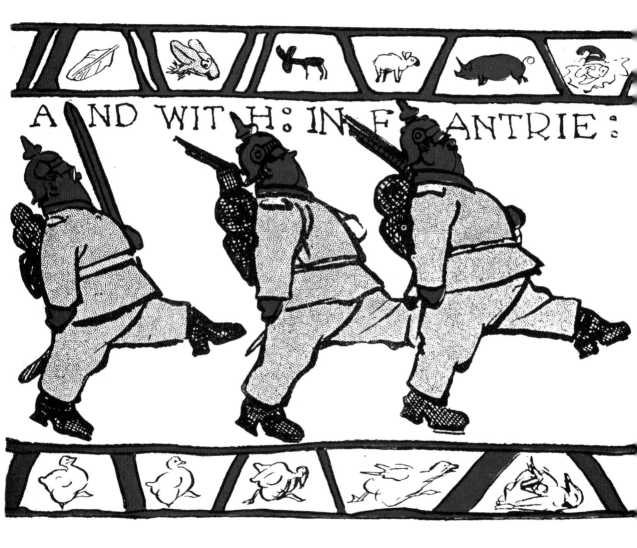

AND WITH: IN F ANTRIE:

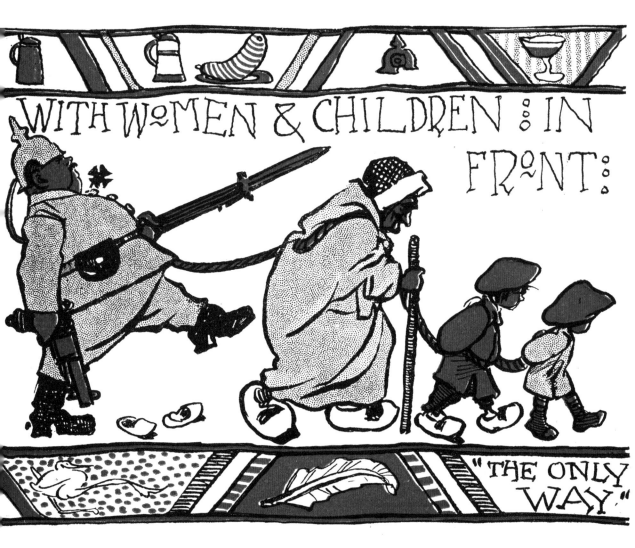

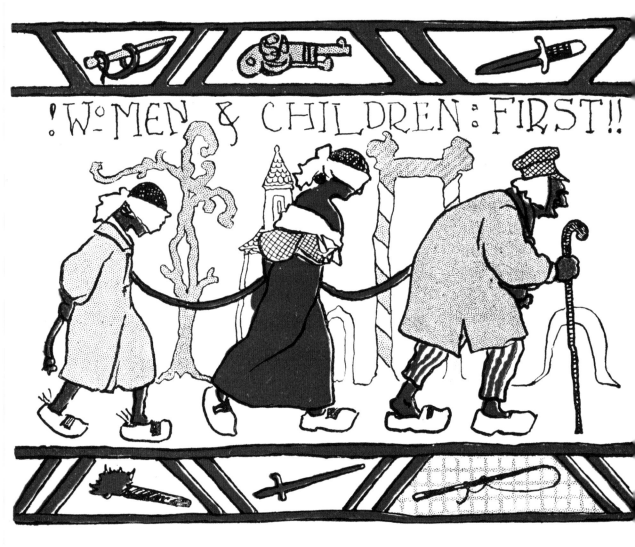

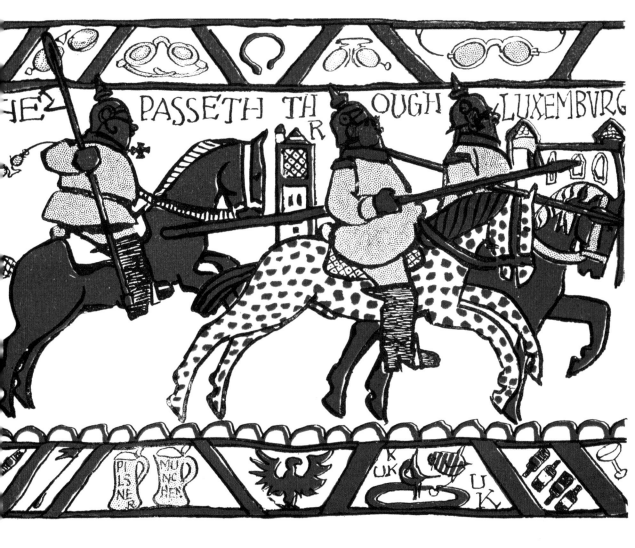

PASSETH TH·R·OUGH LUXEMBVRG

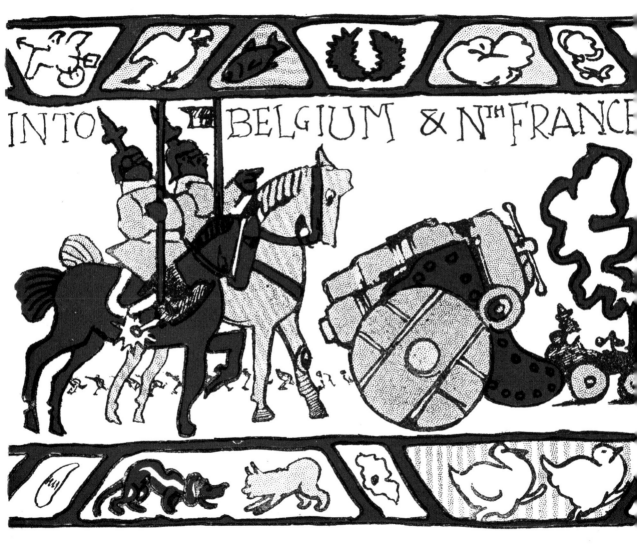
INTO BELGIUM & Nᵗʰ FRANCE

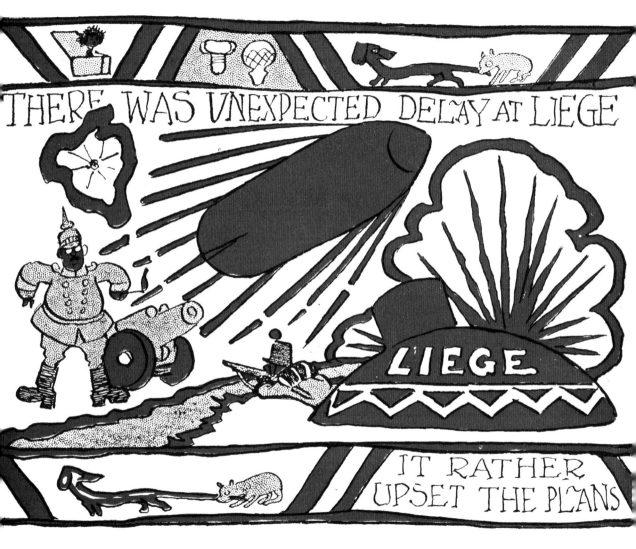

THERE WAS UNEXPECTED DELAY AT LIEGE

LIEGE

IT RATHER
UPSET THE PLANS

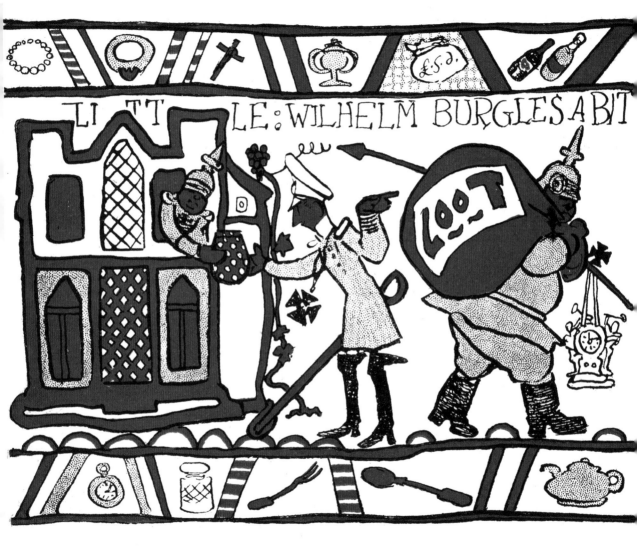

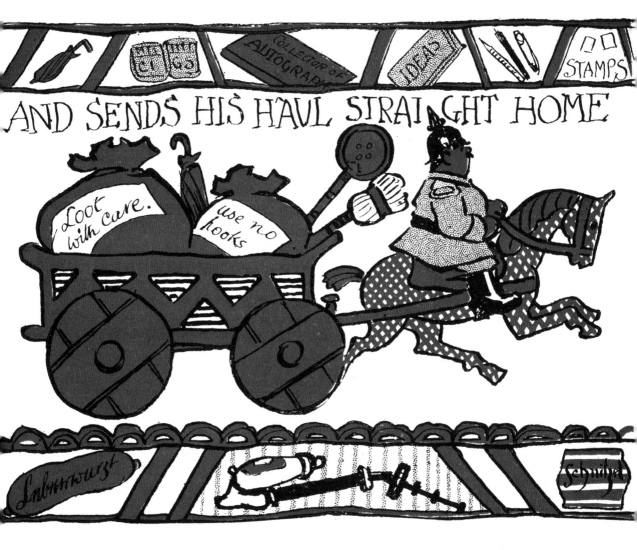

AND SENDS HIS HAUL STRAIGHT HOME

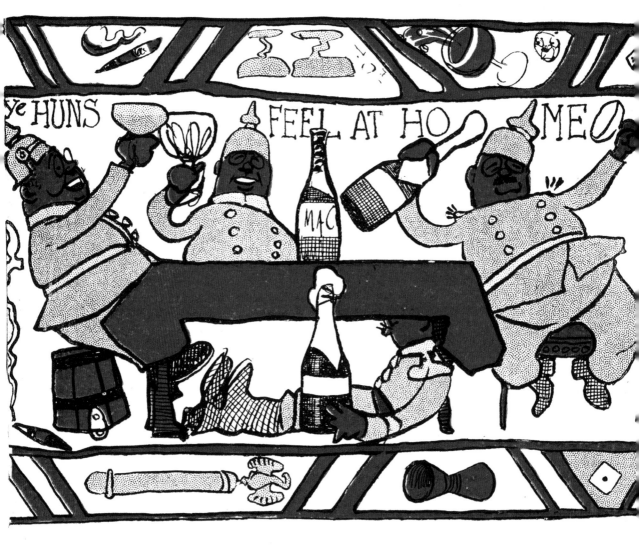

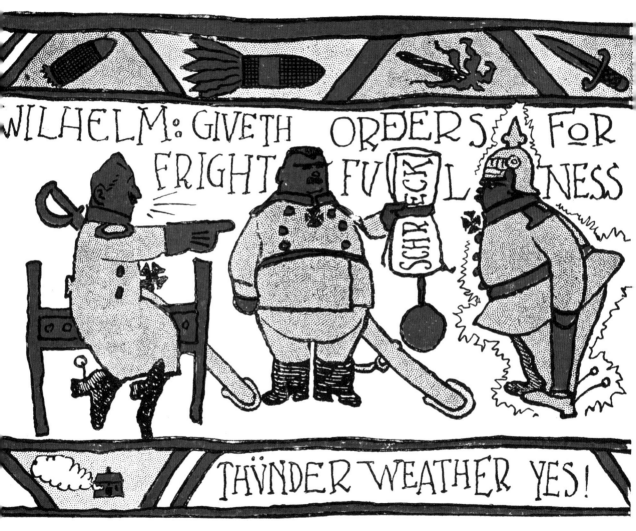

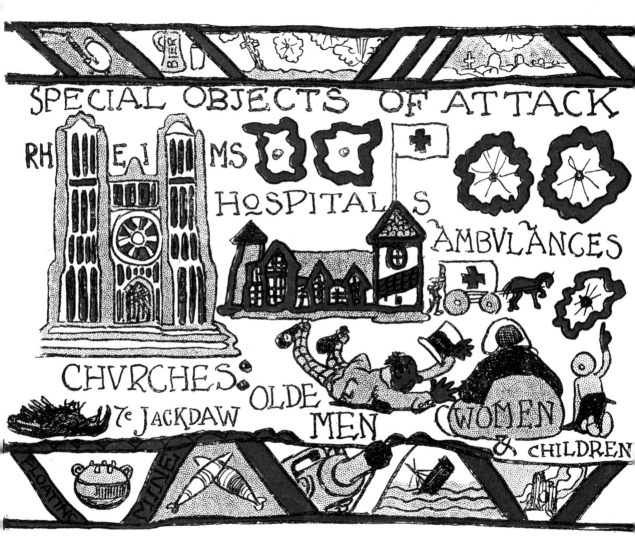

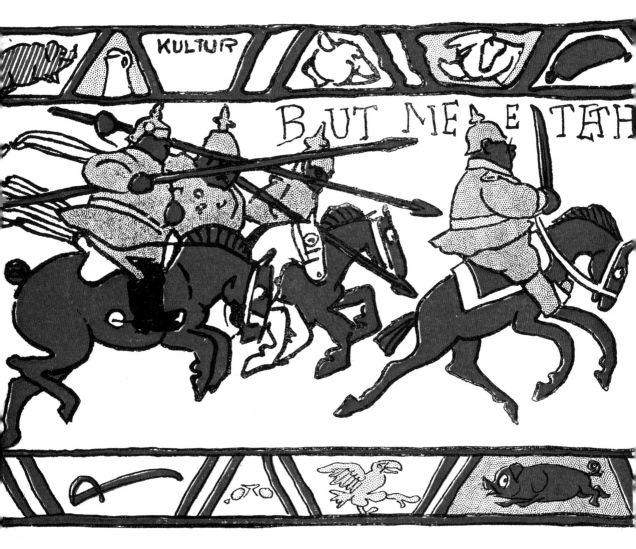

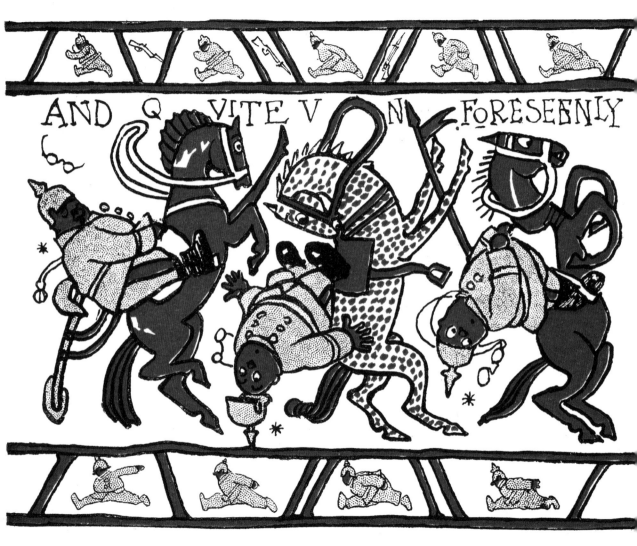

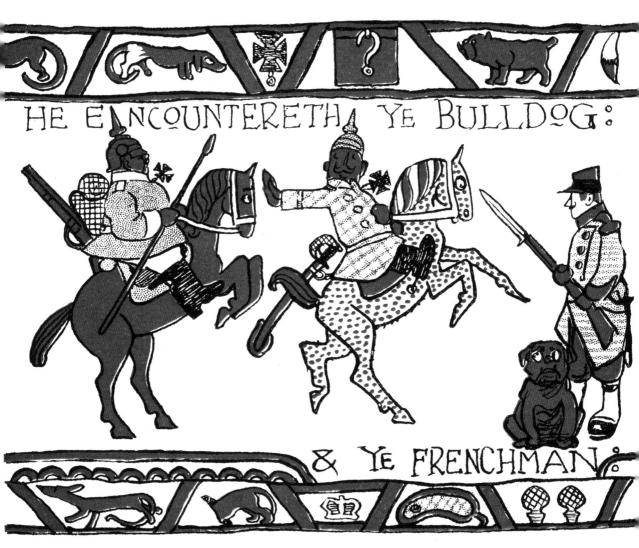

HE ENCOUNTERETH YE BULLDOG:

& YE FRENCHMAN·

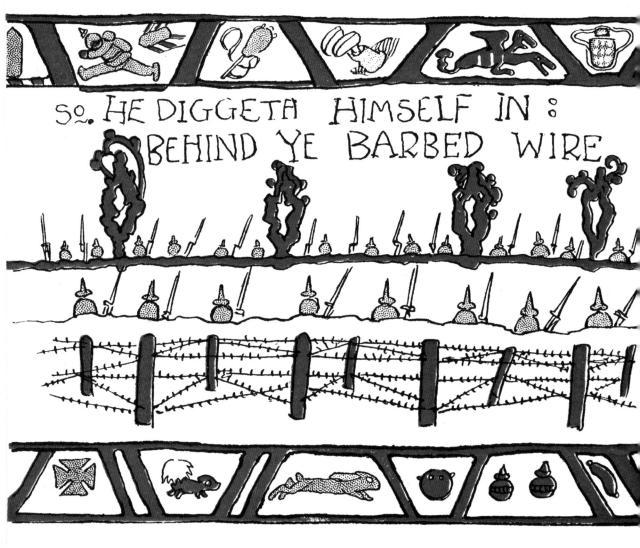

SO. HE DIGGETA HIMSELF IN :
BEHIND YE BARBED WIRE

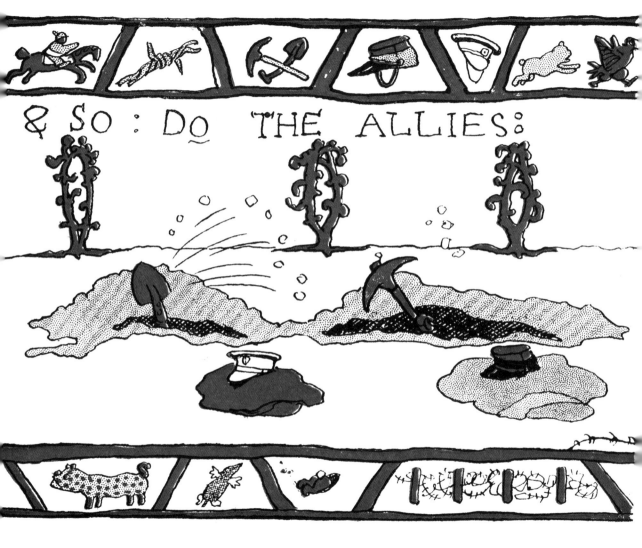

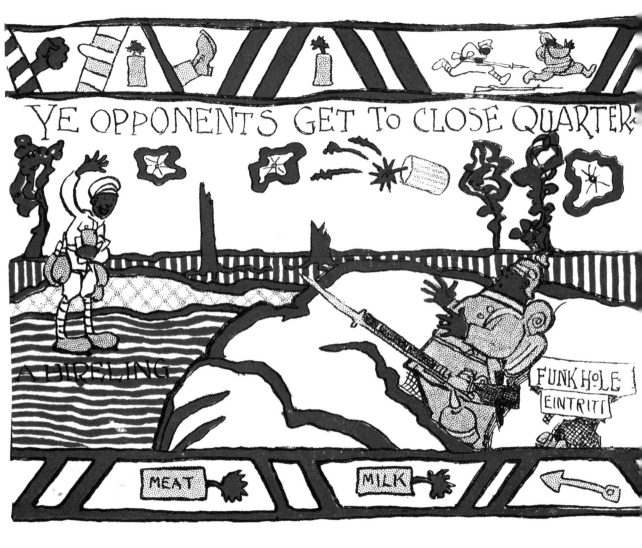

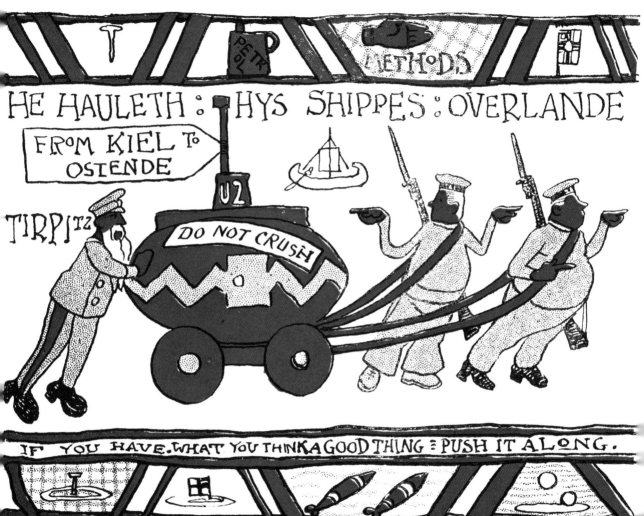

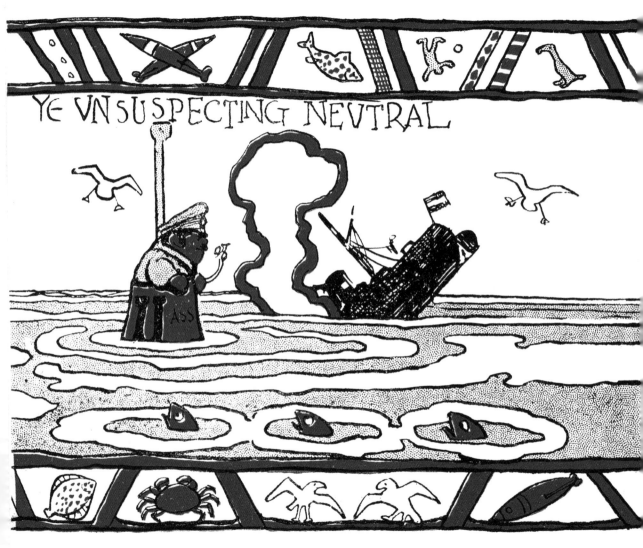

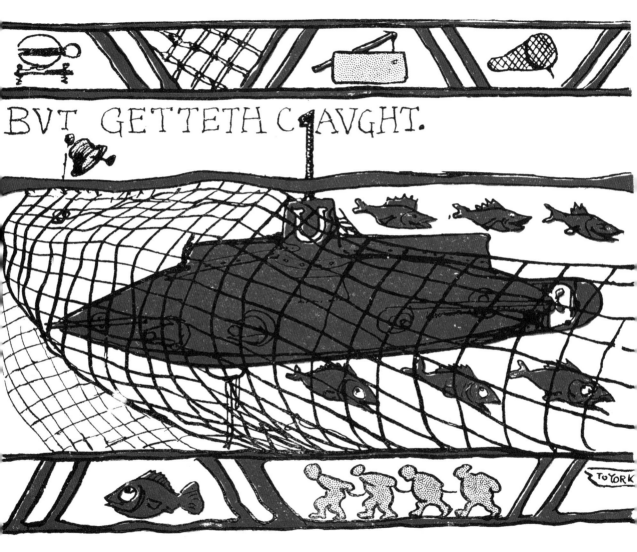

BVT GETTETH CAVGHT.

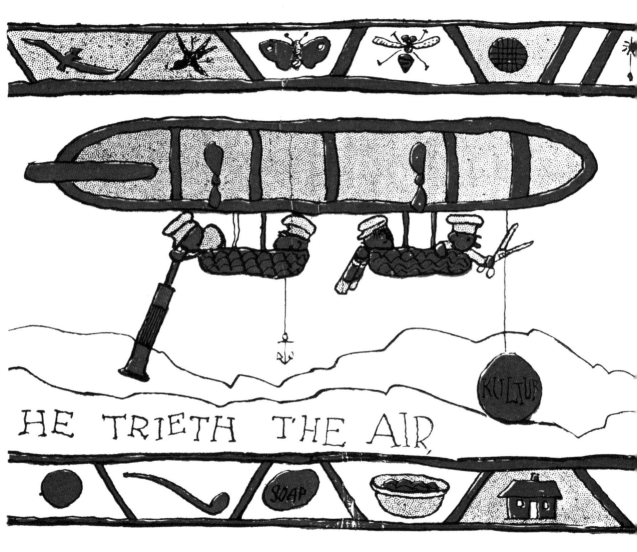

HE TRIETH THE AIR

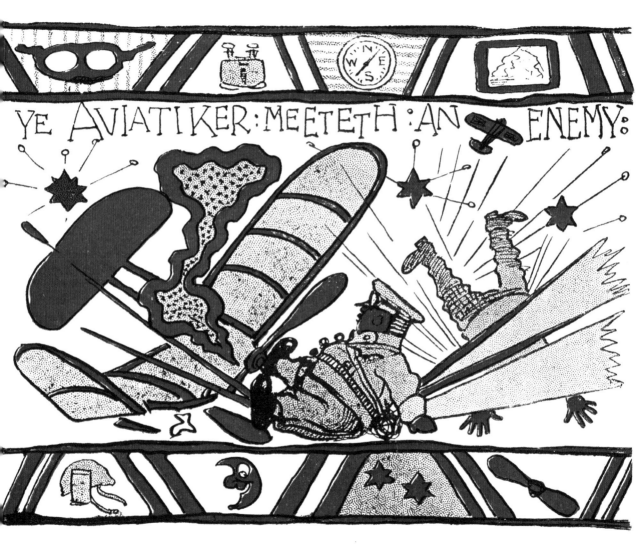

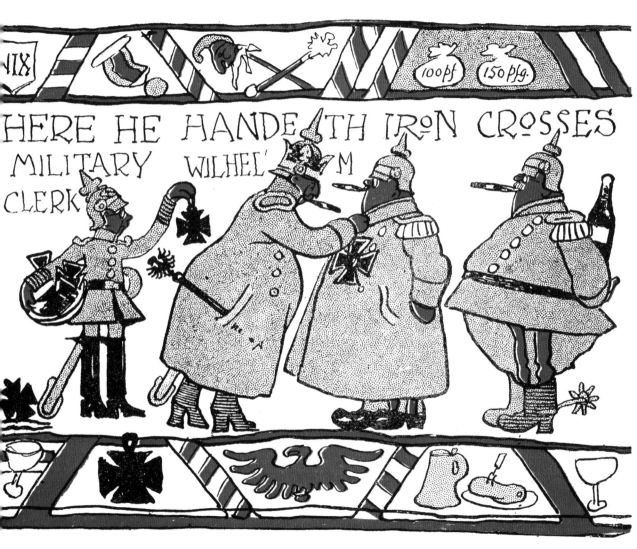

"Ye Berlyn Tapestrie" is founded on
the famous Bayeux Tapestry which
recorded incidents of the Invasion of
England by William the Conqueror,
A.D. 1066.

Ye Studio Offices London:

PRINTED BY EDMUND EVANS TD., LONDON, S.

This edition published in 2014 by the Bodleian Library
Broad Street
Oxford OX1 3BG

www.bodleianbookshop.co.uk

ISBN: 978 1 85124 416 4

First published as *Ye Berlyn Tapestrie: Wilhelm's Invasion of Flanders: Pictured by John Hassall*, c.1915.

Designed and typeset by Dot Little in 11 on 15 Minion at the Bodleian Library
Printed and bound in China by C&C Joint Printing Ltd

British Library Catalogue in Publishing Data
A CIP record of this publication is available from the British Library